Inuit Spirit

A Colouring Book by Artist Germaine Arnaktauyok

INHABIT
MEDIA

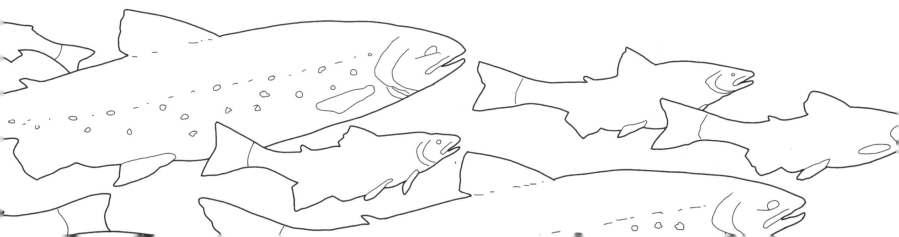

Published by Inhabit Media Inc.
www.inhabitmedia.com

Inhabit Media Inc. (Iqaluit) P.O. Box 11125, Iqaluit, Nunavut, X0A 1H0
(Toronto) 191 Eglinton Avenue East, Suite 301, Toronto, Ontario, M4P 1K1

Design and layout copyright © 2016 by Inhabit Media Inc.
Text copyright © 2016 by Germaine Arnaktauyok
Images by Germaine Arnaktauyok copyright © 2016 Inhabit Media Inc.

Edited by Neil Christopher and Kelly Ward
Design by Danny Christopher and Astrid Arijanto
Digital colours by Jonathan Wright (front cover) and Amanda Sandland (inside front cover, back cover)

This project was made possible in part by the Government of Canada.

We acknowledge the support of the Canada Council for the Arts for our publishing program.

Printed in Canada.

ISBN: 978-1-77227-126-3

 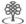

Inuit Spirit

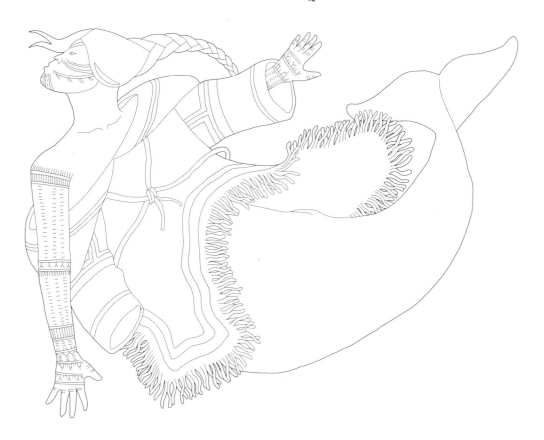

A Colouring Book by Artist Germaine Arnaktauyok

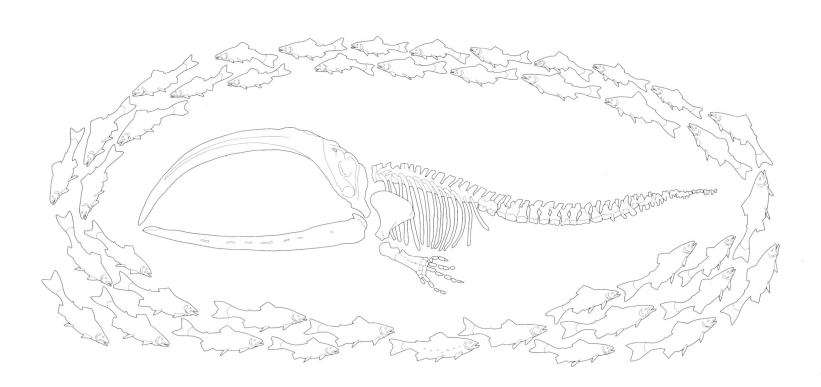

Introduction

As co-owner of Inhabit Media, I have had the pleasure of working with Germaine Arnaktauyok on several book projects over the last few years. Her work has always been steeped in traditional Inuit beliefs and grounded in Inuit traditional life, and as such has been a continual inspiration to many young Inuit artists and a source of pride for all residents of the Arctic.

In addition to the mainstream acclaim that Germaine has received—having her work shown in galleries across North America and receiving many high-profile commissions—Germaine has remained, at heart, a Northerner's artist. Northerners are particularly proud to display Germaine's prints in their homes, as her attention to cultural detail, and her deeply felt responsibility to depict traditional life as it really was, lends an authenticity to her work that few can rival. When depicting plants, animals, traditional clothing, even the seasonal tundra, Germaine draws on her own memory to ensure that level of authenticity. And when memory fails to fully capture a topic, Germaine spends hours going through books, old photos, and other resources to ensure that her work accurately portrays traditional life in the North.

Inhabit Media is proud to continue to bring Germaine's work to readers within the Arctic and beyond. With *Inuit Spirit*, we hope to give you a taste of what life is like in the Arctic, and to introduce you to one of the North's most talented artistic voices.

Neil Christopher
Iqaluit, Nunavut

This image represents the Inuit legend of day and night. In this traditional story, an argument between a fox and a raven is said to have caused day and night. Before this disagreement, the world only knew a twilight sky, lacking the brightness of day and the darkness of night.

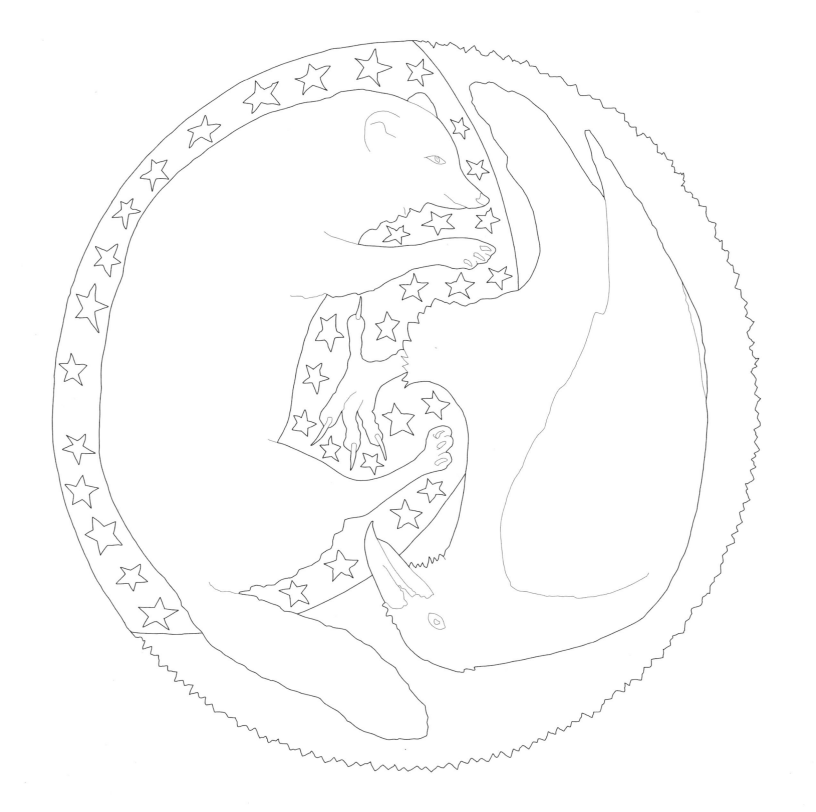

This mother carries a baby in her *amauti*—a woman's parka designed to carry a baby—while this man wears traditional fishing clothing and carries a *kakivaak* fishing spear. Although these are traditional items, they are still used today in the North.

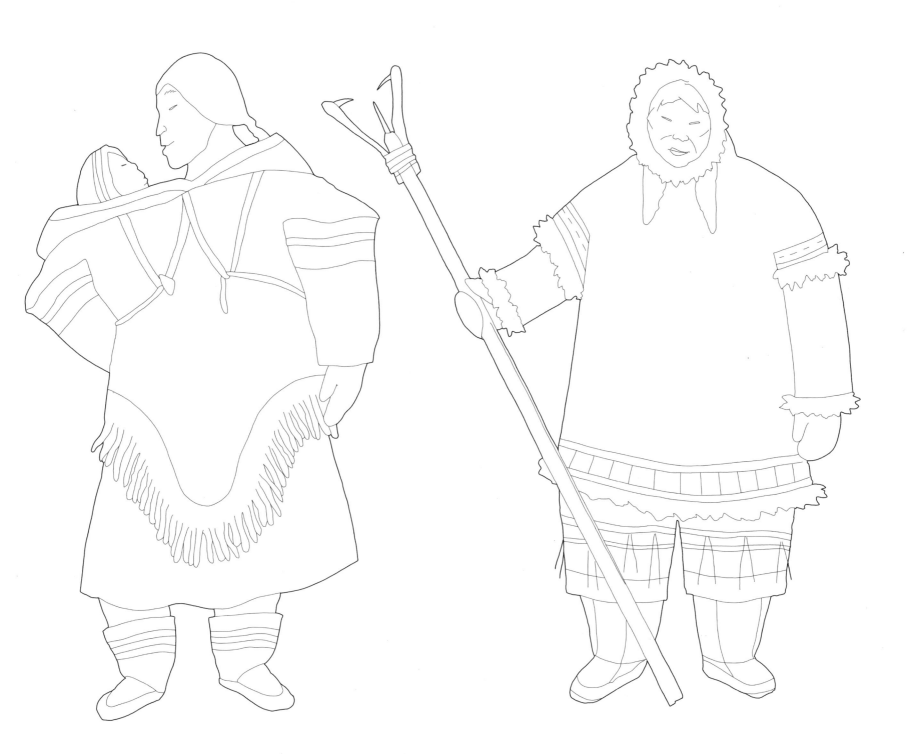

These female drummers are wearing different styles of clothing traditionally found in the Eastern Arctic. Inuit clothing varies from region to region. You can tell where someone is from by the style of traditional clothing they wear.

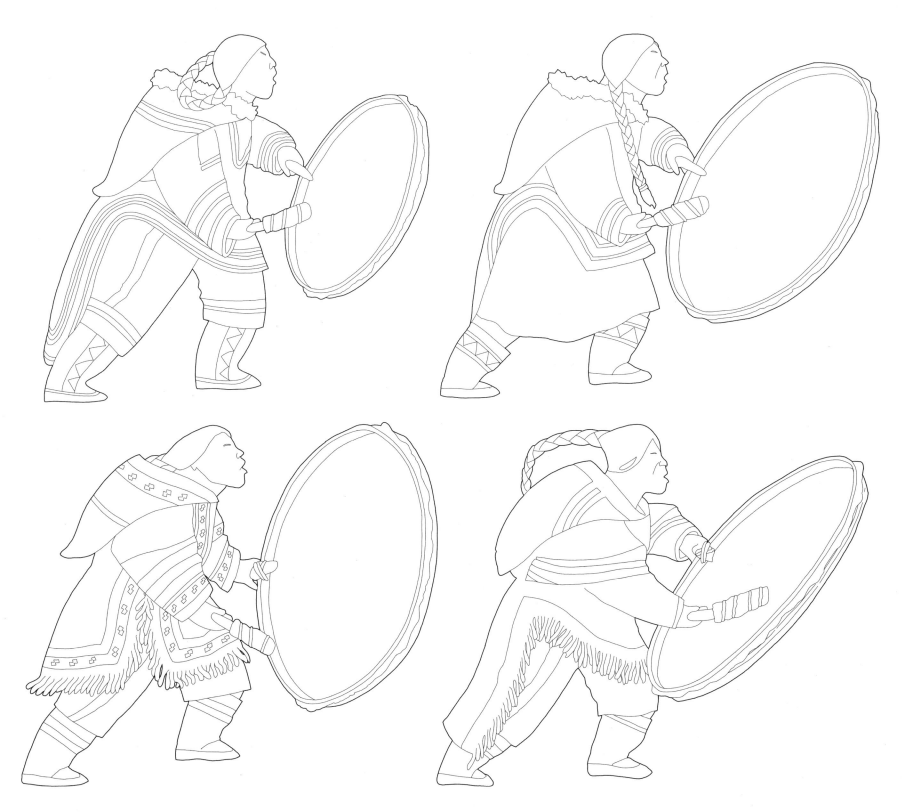

This image depicts either an Inuk hunter standing on the skull of a *nanurluk*—the giant polar bear told of in Inuit legends—or a member of one of the many races of little folk told of in Inuit lore standing on a regular polar bear skull.

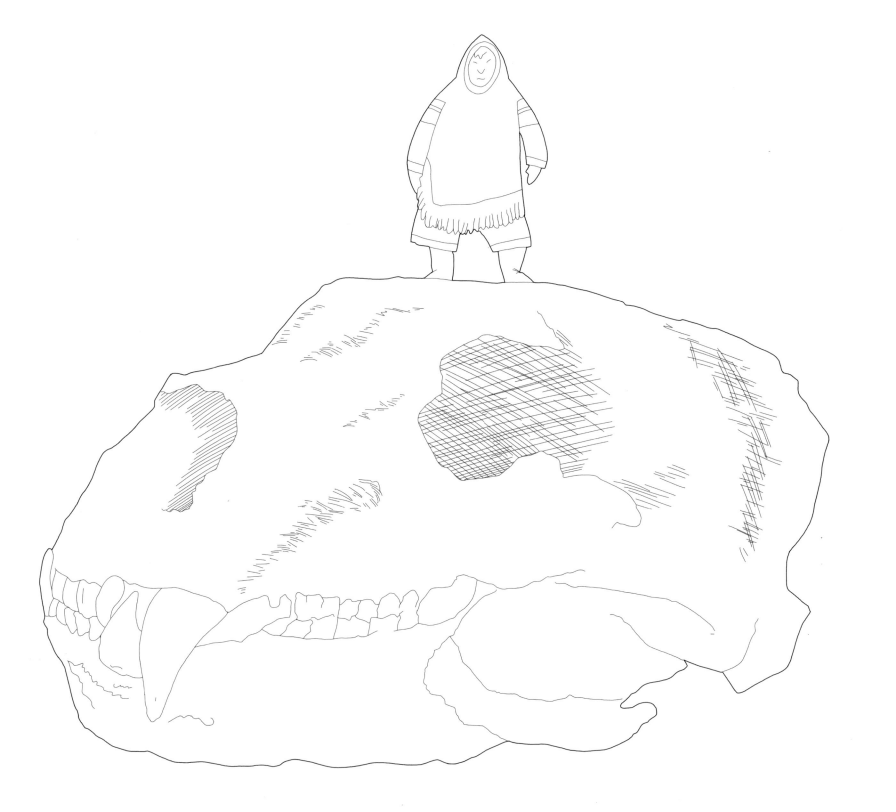

This is the *mahahaa*. In Inuit legends, the mahahaa is a creature with long fingernails that is said to tickle people to death.

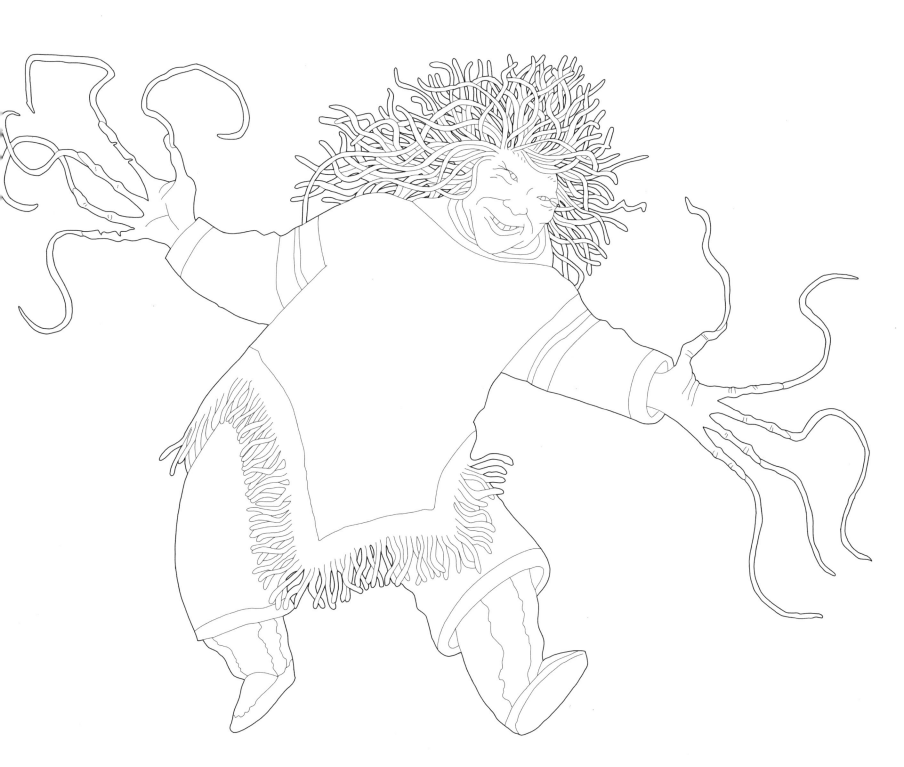

This is a *taliillajuuq*. She is a member of a race of beings—said to have the upper body of a human and the lower body of a beluga—that lives under the Arctic sea.

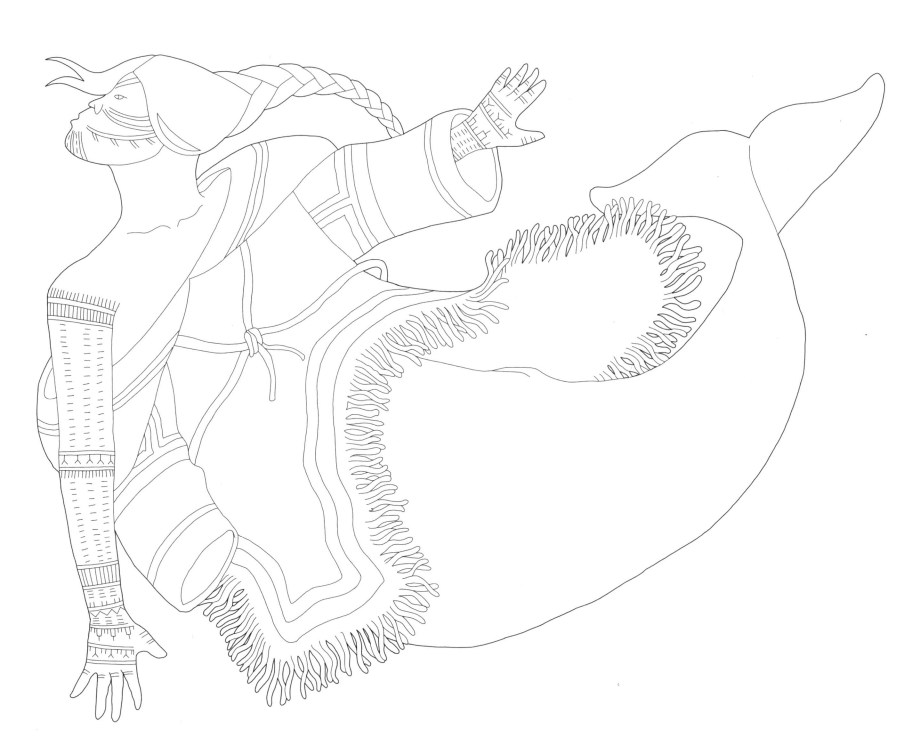

These are legendary creatures called *qallupilluit*. They live in the sea along the shoreline and love to grab little children who are playing on the ice. Our parents often told us not to play on the ice when it was breaking up in the spring, for fear of being snatched by one of these creatures.

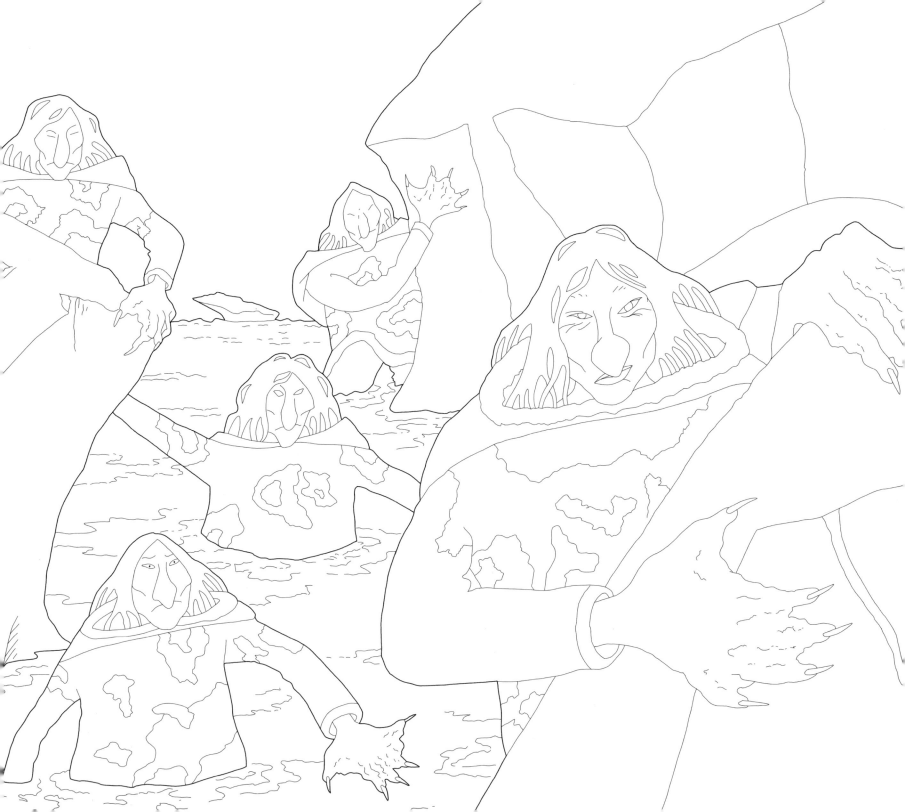

Here two men out hunting from their kayaks are being followed by a nanurluk, the legendary giant polar bear from Inuit stories.

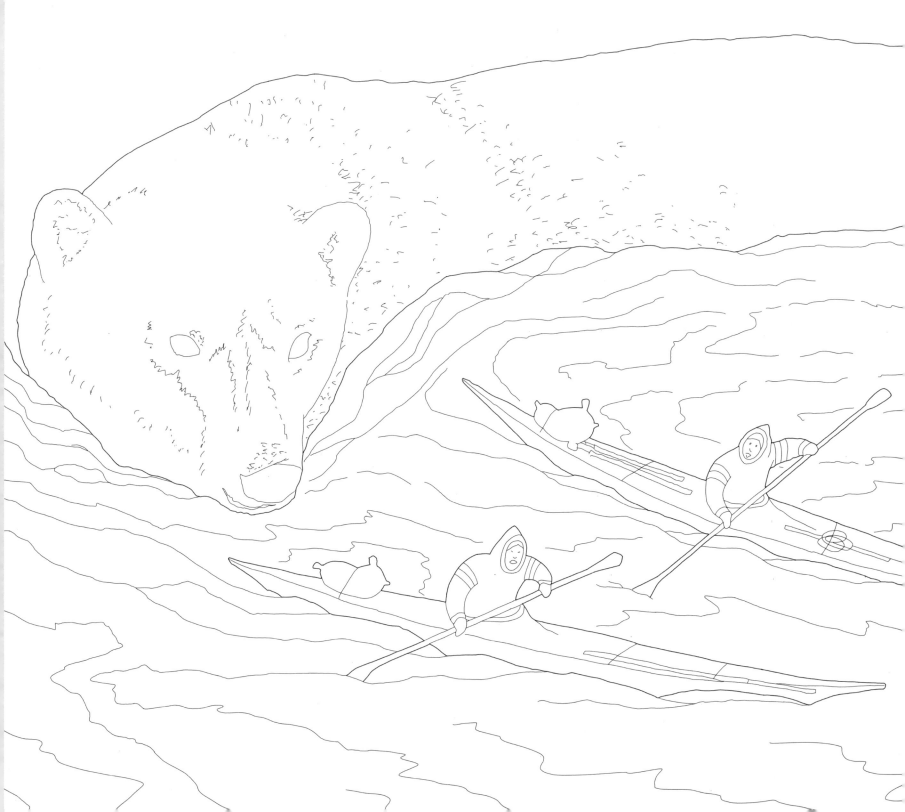

In this image, a woman finds a baby born from the land—an earth child. In Inuit legends, Inuit sometimes found babies on the land as they travelled. It is said that baby boys were difficult to find. Women had to travel very far in order to find one.

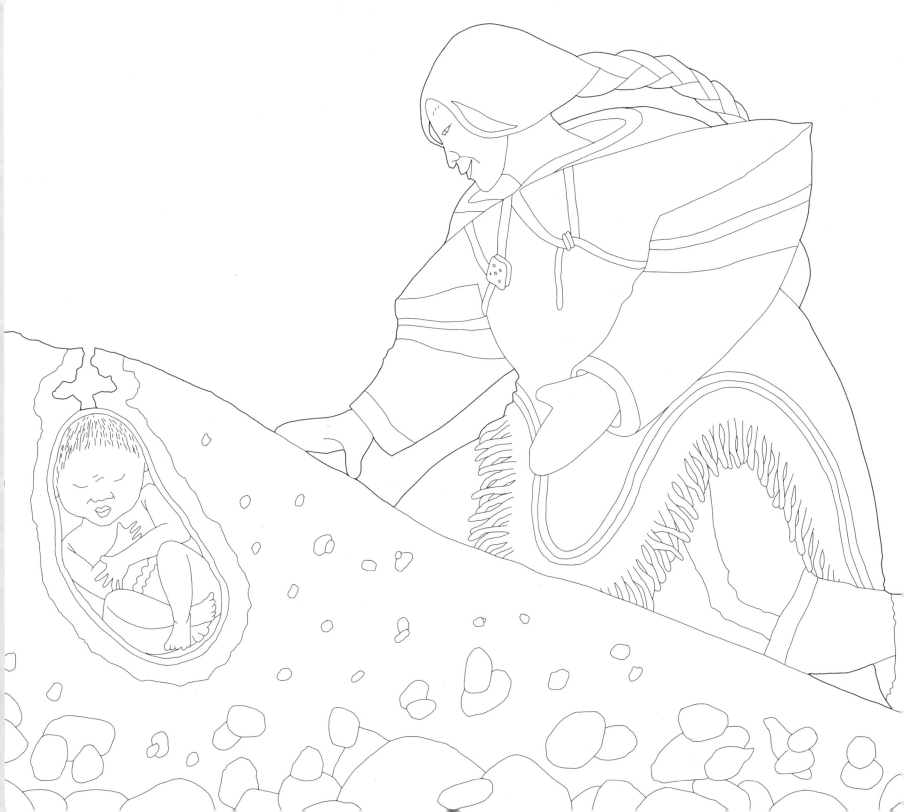

This is an image of the Arctic tundra in summer. In summer, the tundra explodes with colours as many vibrantly coloured plants and flowers appear to enjoy the long summer days.

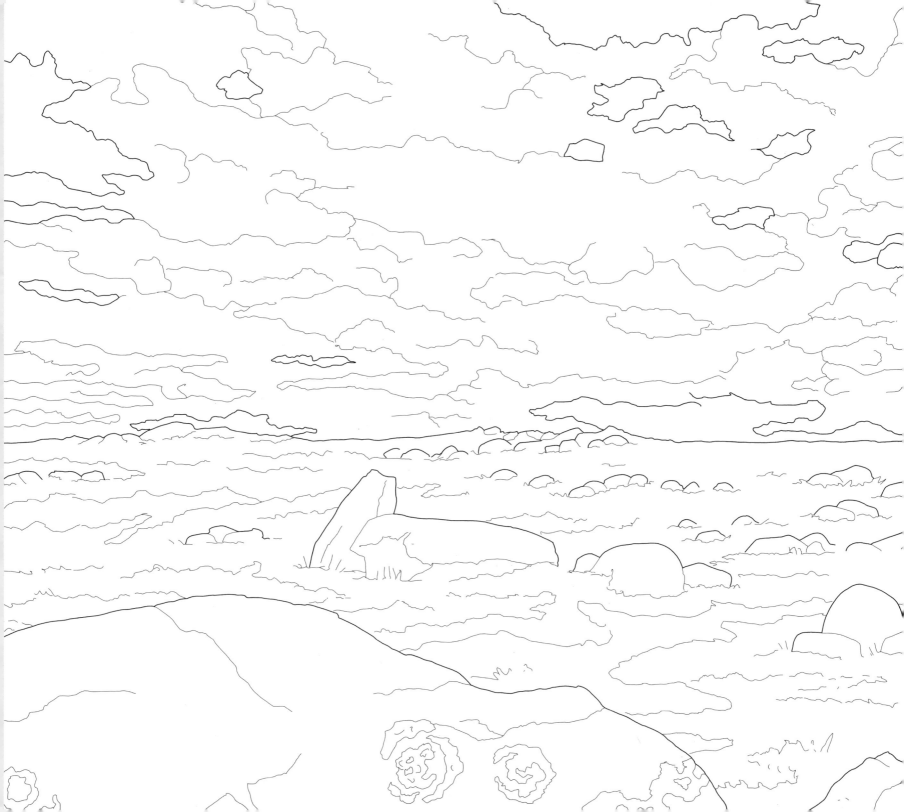

This is a close-up view of red and yellow lichen. Lichen is very common in the Arctic. In winter, lichen is the main food source for caribou across the North.

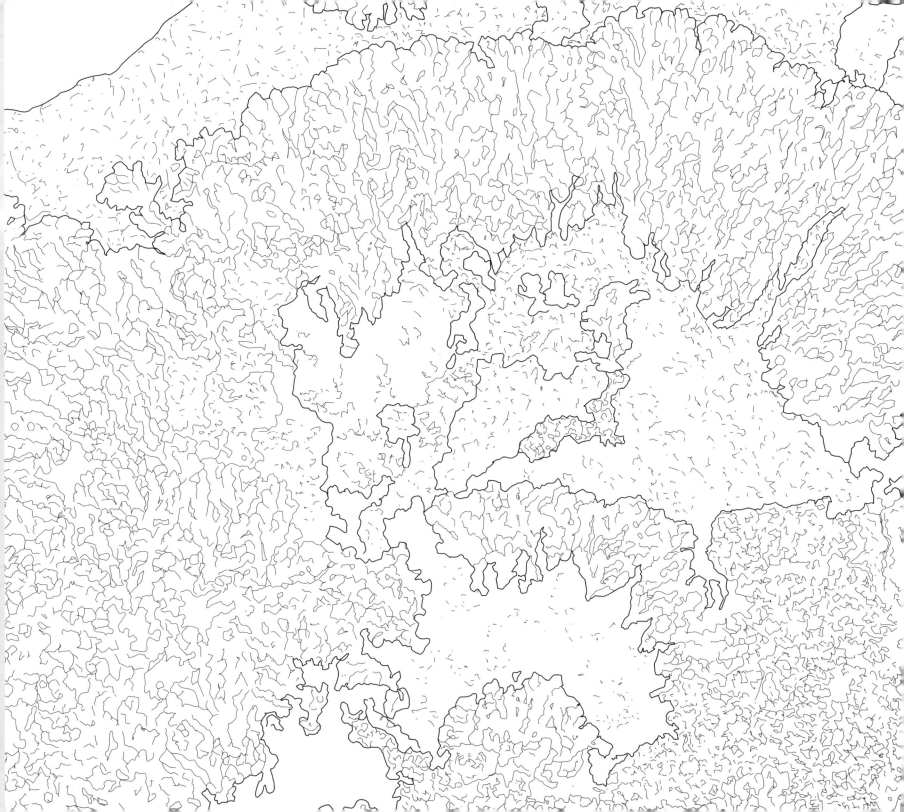

This is an image of plants that grow on the summer tundra. Snow buttercup, birdfoot buttercup, nodding campion, Lapland pincushion, Arctic camomile, dwarf fireweed, Arctic poppy, and lichen can all be seen in this image. All of the parts of the dwarf fireweed plant are edible, and when cooked, the leaves of this plant taste like spinach!

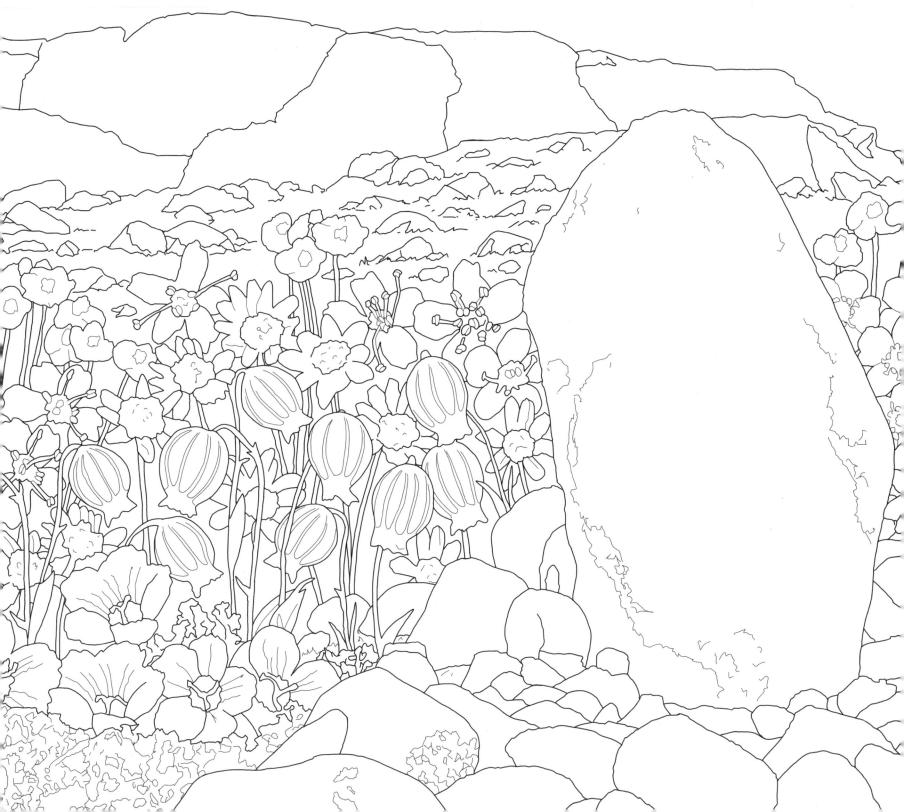

Purple saxifrage, seashore camomile, snow buttercups, and longstalked starwart are pictured here growing on the summer tundra. Purple saxifrage flowers are edible, and the leaves of the plant can be boiled into a tea.

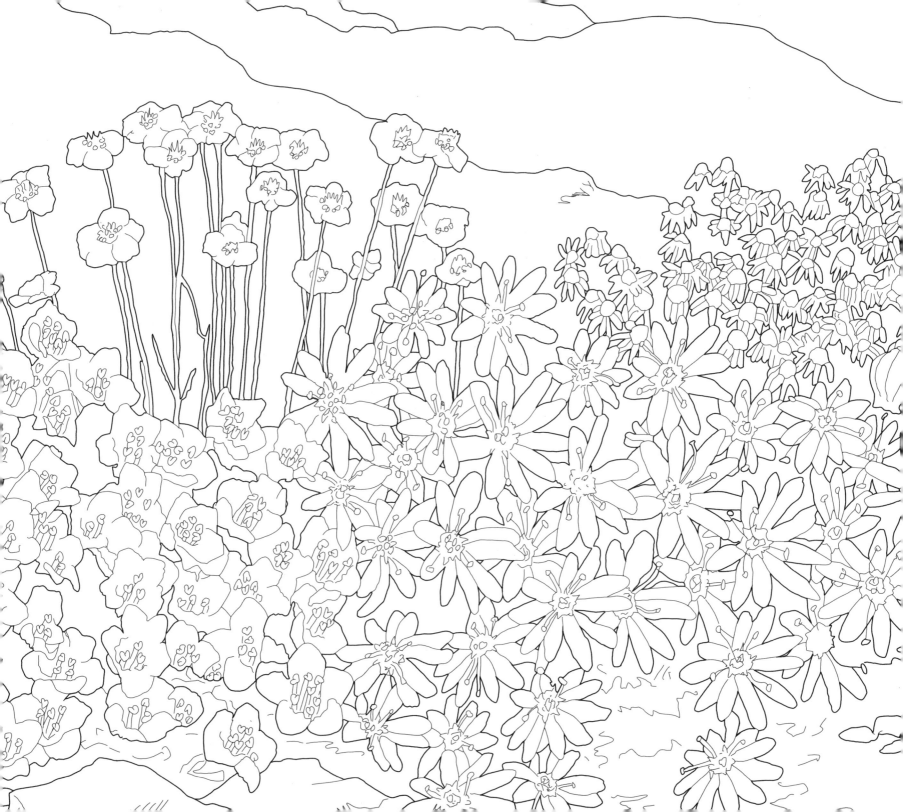

This image depicts various stages of growth of the Arctic willow plant. Arctic willow leaves are edible, and the roots of the plant can be chewed to treat a toothache.

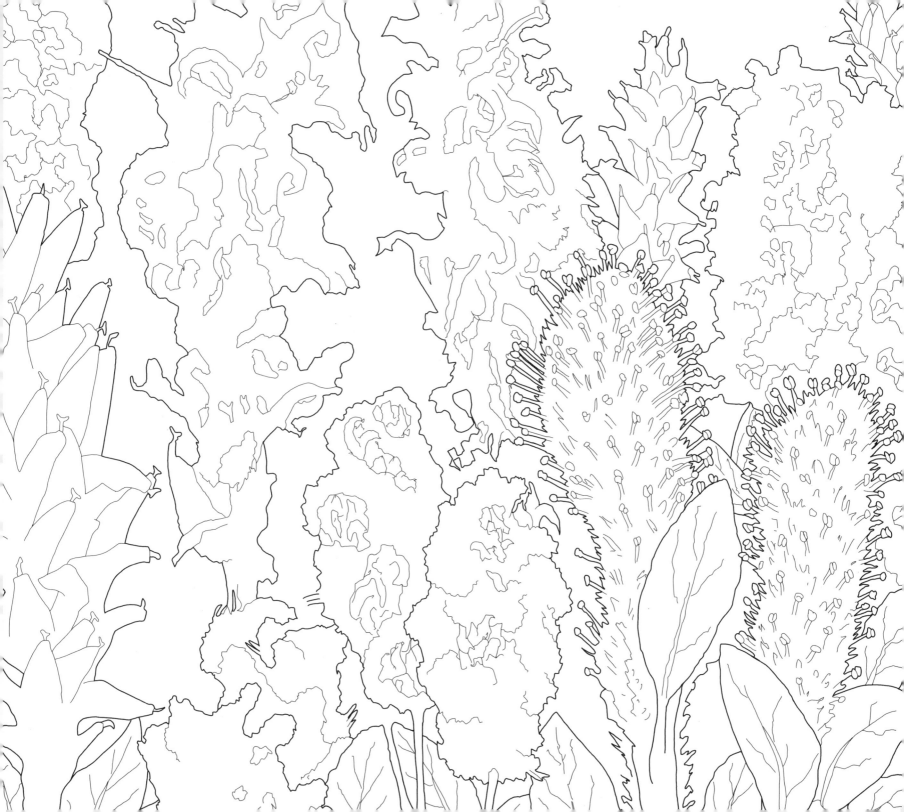

This is a close-up view of Arctic cotton. This plant has many traditional uses. The fluffy flower head can be eaten to soothe a sore throat, and it can also be used to make a wick for a traditional stone lamp known as a *qulliq*.

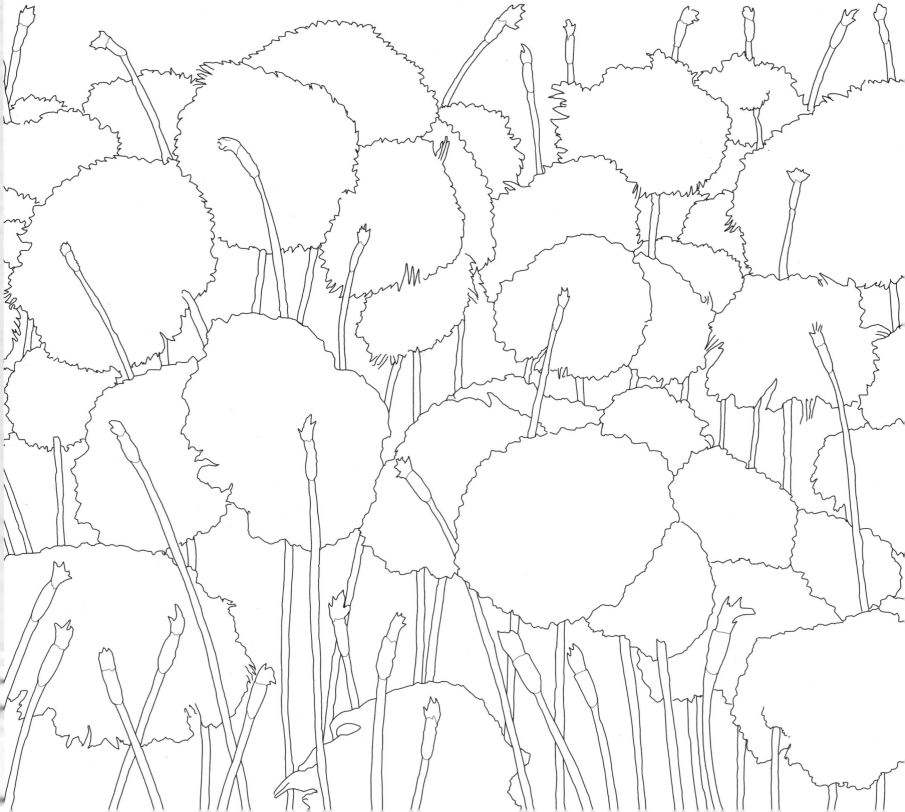

Tundra plants, including white mountain avens, dwarf fireweeds, and oxytropes, are pictured here. Before modern calendars were introduced to Inuit, mountain avens were used to mark the progression of the seasons. Once the plant loses its flowers, tightly coiled hairs grow from the stem. When the hairs began to uncoil, Inuit knew that autumn was soon to arrive.

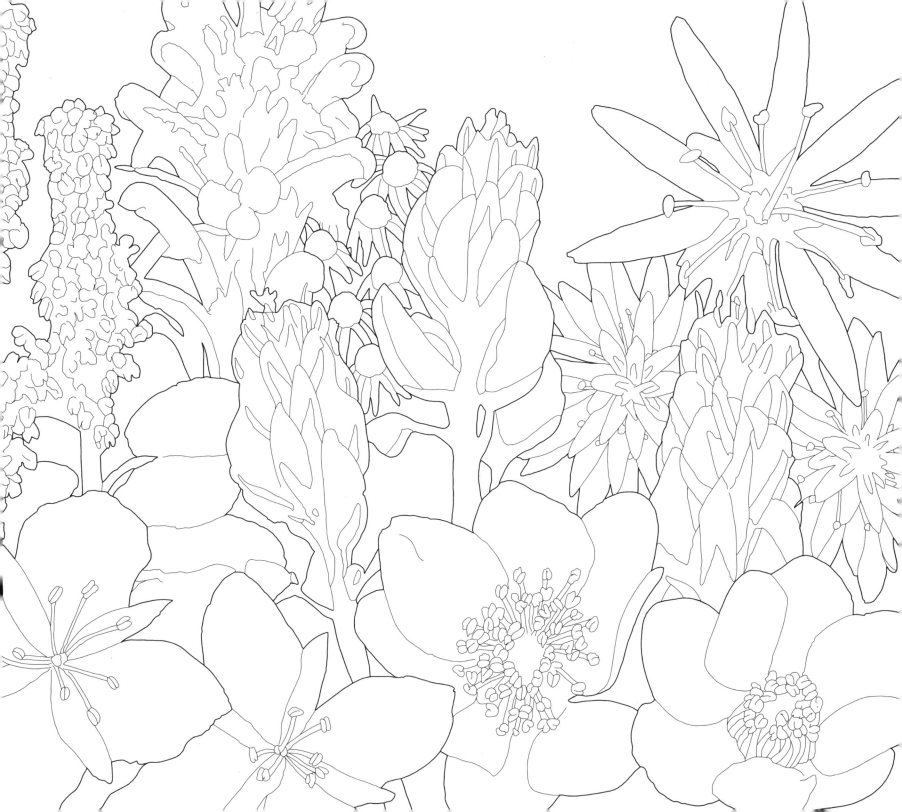

These dark blue tundra berries are called bilberries. These berries were traditionally eaten raw or made into a pudding, and the leaves could be boiled as a tea.

This is a close-up view of purple saxifrage flowers. In the spring, caribou eat so many purple saxifrage flowers that their muzzles are often stained purple.

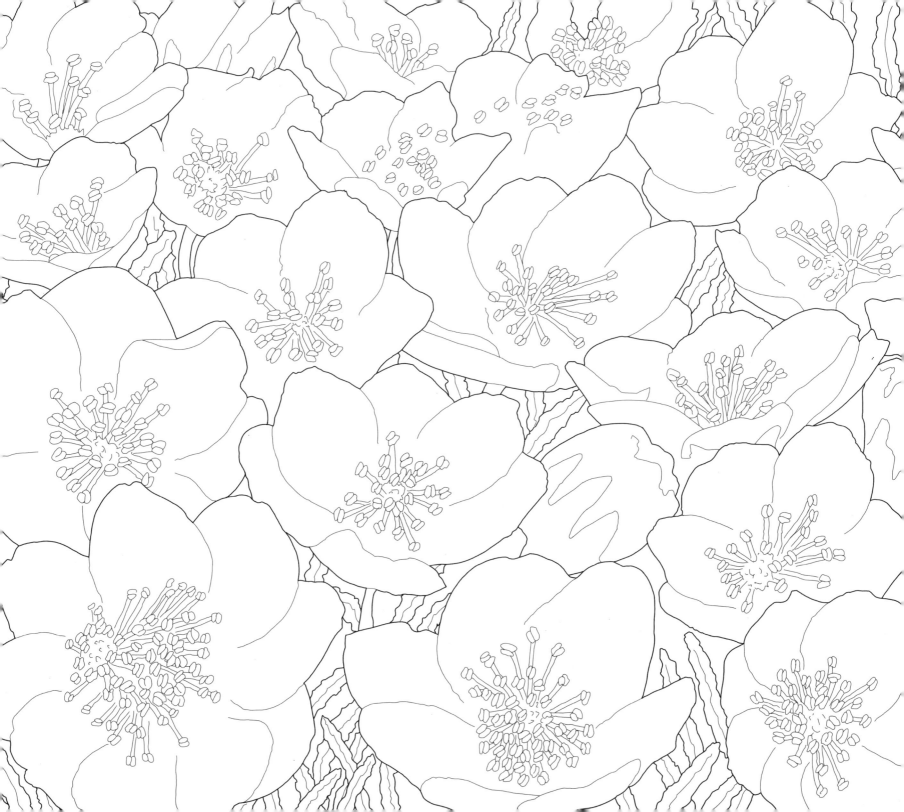

These are ptarmigans on the summer tundra. The feathers of these birds are mottled brown and black in the summer months, so they can hide from predators.

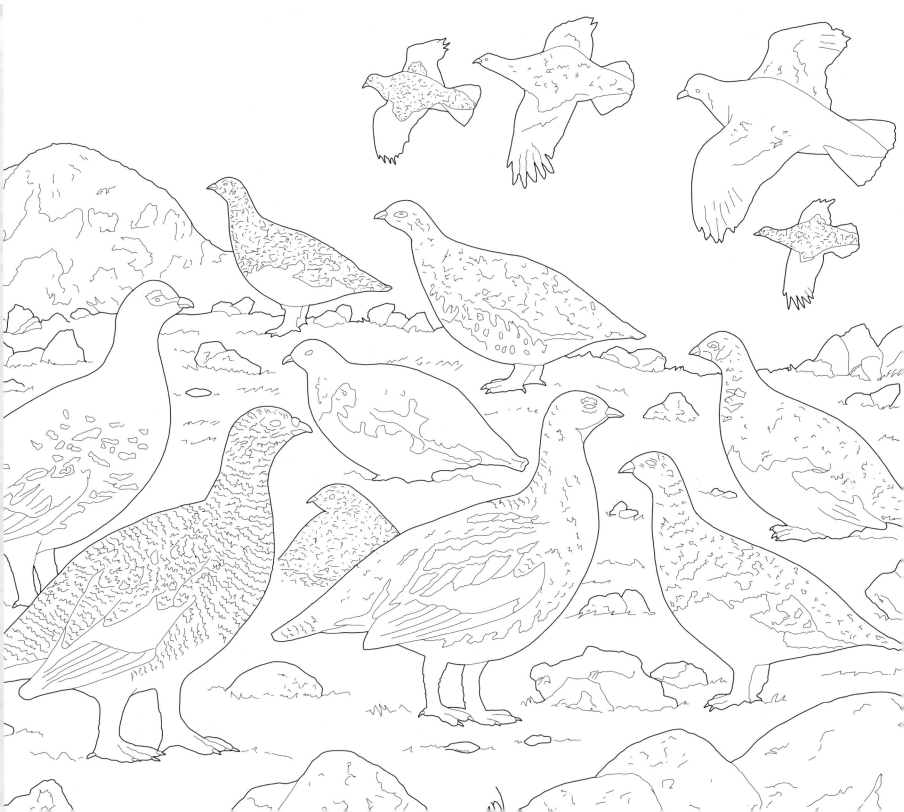

Here seagulls gather by the seashore. Seagulls are a common sight on northern beaches.

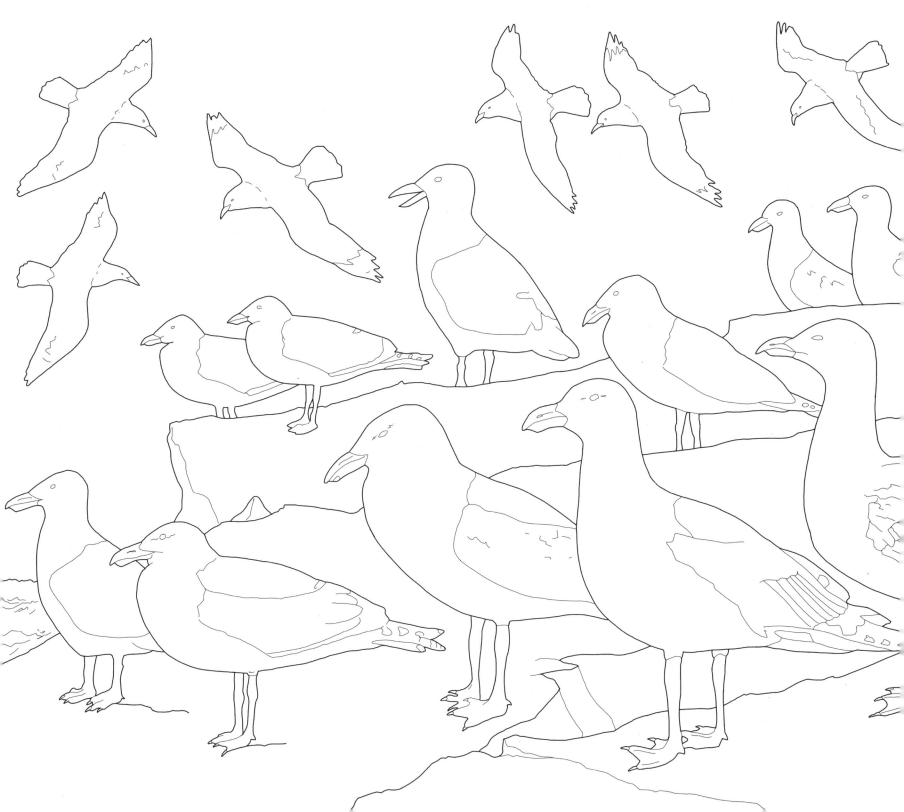

This image depicts a school of Arctic char.

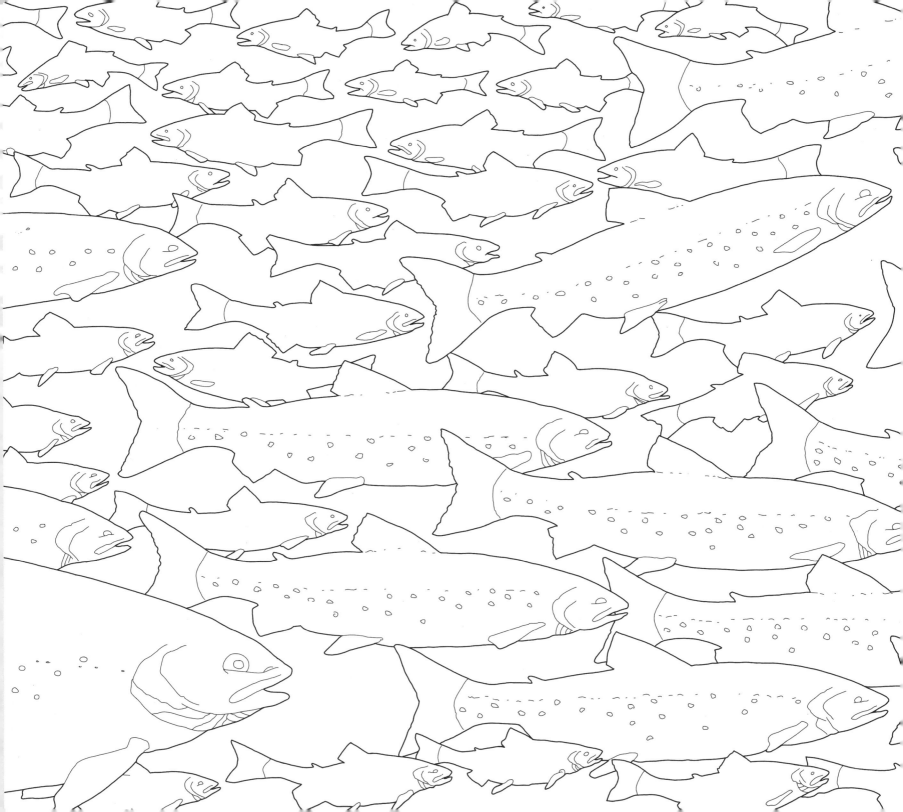

This image shows various Arctic sea mammals, including walruses and minke whales.

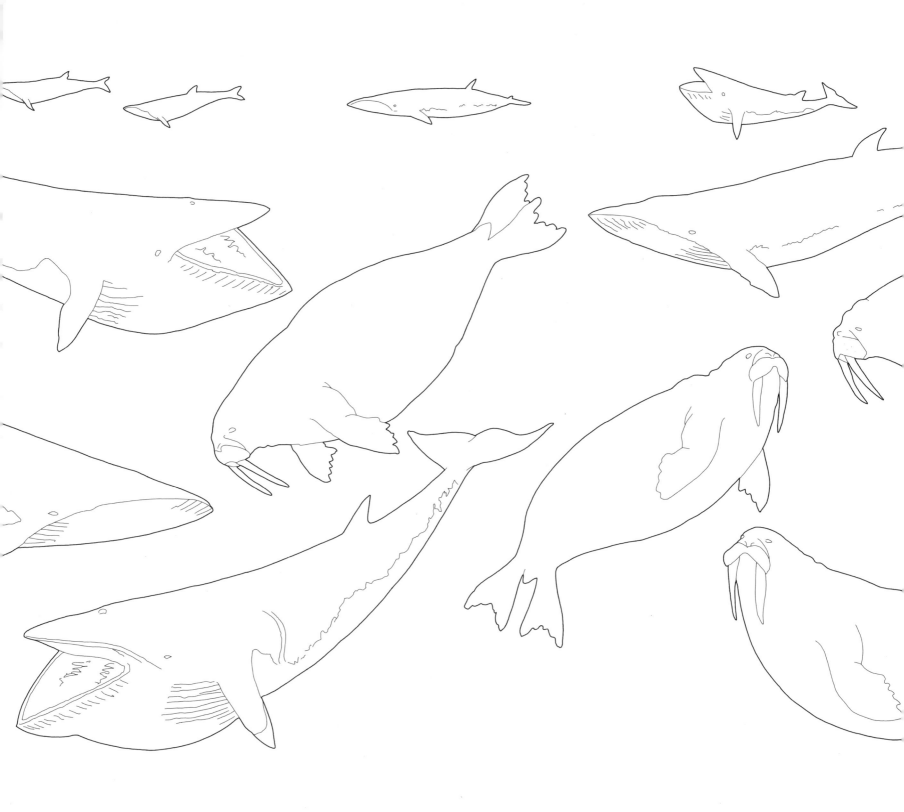

This is a view of plankton, as it appears under a microscope.

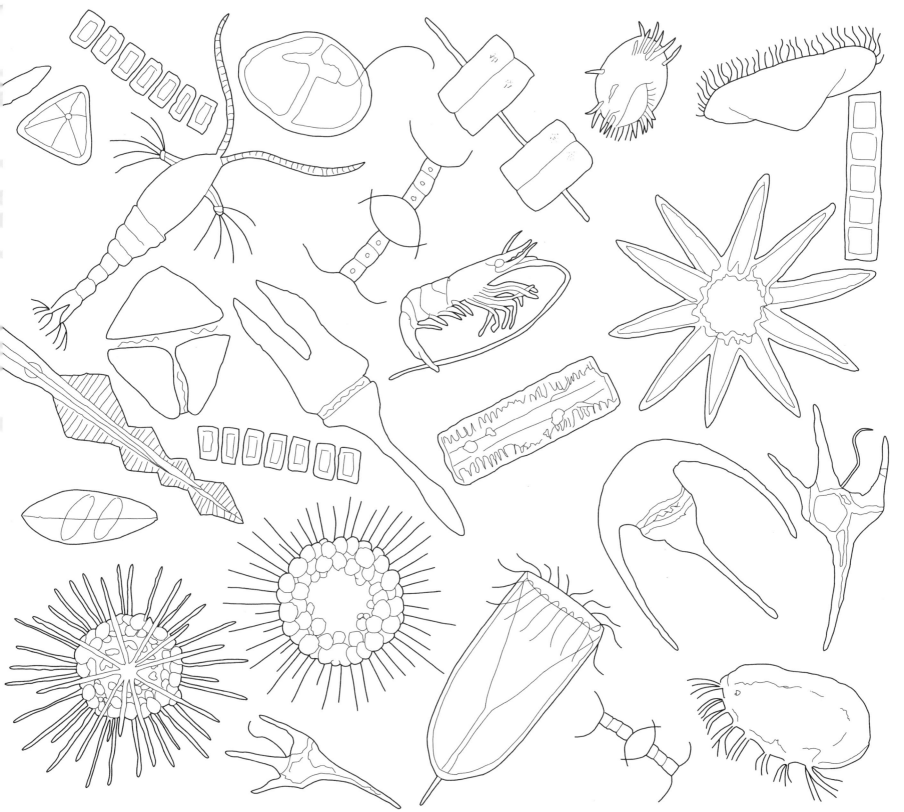

This is Sedna, the woman often known as the mother of the sea mammals. It is said that most of the sea mammals that are so important to Inuit were created from Sedna's severed fingers. In a version of the legend told in the Eastern Arctic, Sedna keeps the sea mammals in her hair.

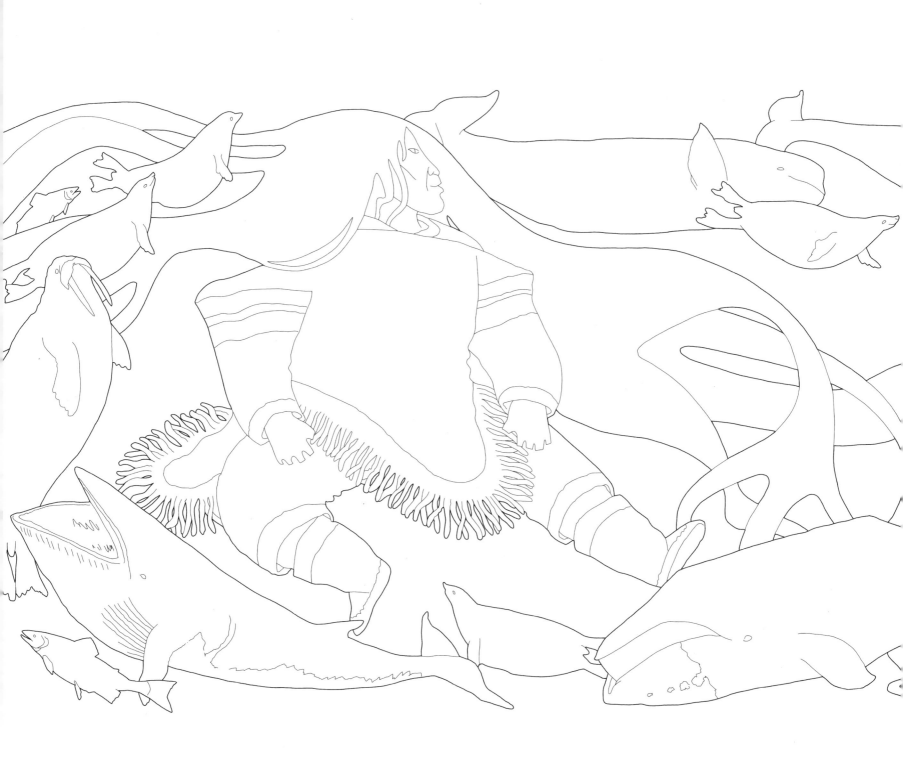

Here Sedna is depicted overseeing her sea mammals. If Sedna is pleased, she will allow the sea mammals to be hunted and caught so that people do not go hungry.

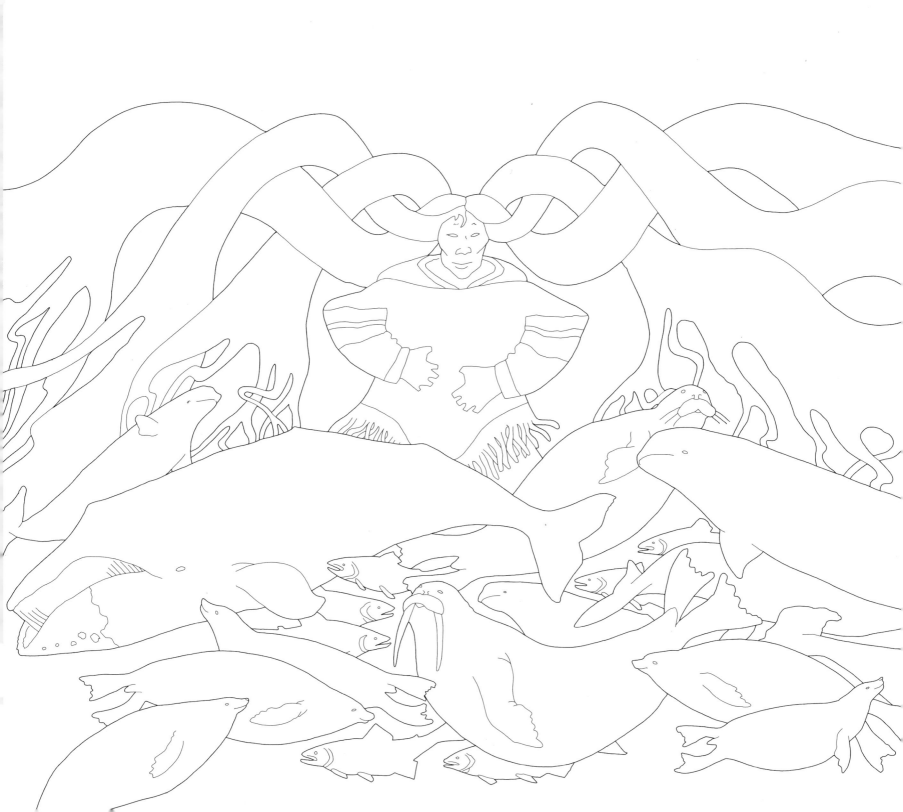

This is a close-up of Sedna's face with sea mammals in her hair.

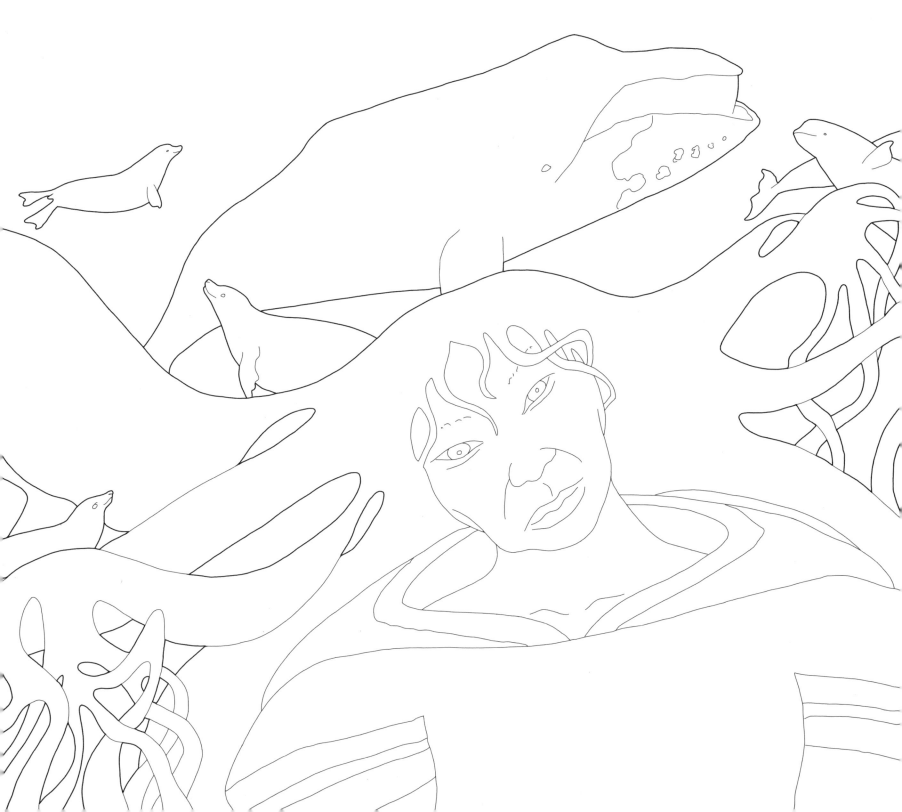

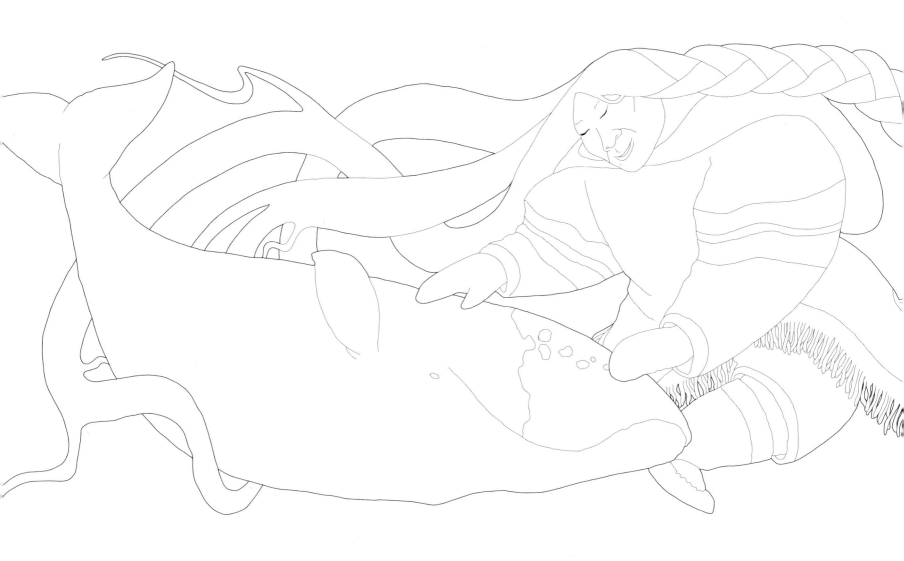

About Germaine Arnaktauyok

Germaine Arnaktauyok is an Inuit artist and illustrator, best known for her prints and etchings depicting Inuit myths and traditional ways of life. In 1999, she designed the special edition two-dollar coin commemorating the founding of the territory of Nunavut. She is the co-author, with Gyu Oh, of *My Name is Arnaktauyok: The Life and Art of Germaine Arnaktauyok*, and illustrator of several children's books on Inuit myths. She lives in Yellowknife, Northwest Territories.

About Germaine Arnaktauyok's Colouring Style

Germaine Arnaktauyok is known for the innovative form of pointillism that she employs in her drawings, which is unique to her within the area of Inuit art.

Traditionally, pointillism is a technique of painting and drawing in which small dots of colour are used to create images. Beginning in the 1970s, Arnaktauyok began experimenting with using long, curving lines in a similar fashion. Called "squiggles" by Arnaktauyok, this technique uses varying densities of lines to create light and dark areas in an image. The lines themselves are intended to be continuous and fluid, so that a viewer cannot see where each line begins and where it ends.

The darkest areas of a piece will have very densely drawn lines, while lighter areas of colour are made using looser lines. In very light areas of colour, small dots are employed, as they would be in traditional pointillism. Arnaktauyok uses mostly coloured pencils and coloured ink in her drawings.

Of this style, Arnaktauyok has said, "I think my artwork was influenced by the way I was looking at carvings. They have kind of round, curved lines." Using colour in this way can be a very time-consuming process, with some drawings taking several months to complete. An example of this style can be found on the facing page.